VOL. 3

BERKELEY QUIRKY

BY **TOM DALZELL**
PHOTOGRAPHS BY **JOHN STOREY**
ILLUSTRATIONS BY **TRACI HUI**

H HEYDAY, BERKELEY, CALIFORNIA

Library of Congress Cataloging-in-Publication Data

Names: Dalzell, Tom, 1951- author.
Title: Quirky Berkeley. Volume 3 / Tom Dalzell.
Description: Berkeley, California : Heyday, 2018.
Identifiers: LCCN 2018002082 | ISBN 9781597144315 (pbk. : alk.
paper)
Subjects: LCSH: Eccentrics and eccentricities--California--Berkeley. |
 Domestic space--California--Berkeley. | Berkeley (Calif.)--Description
and
 travel. | Berkeley (Calif.)--Miscellanea.
Classification: LCC F869.B5 D353 2018 | DDC 979.4/67--dc23
LC record available at https://lccn.loc.gov/2018002082

Cover Photographs: John Storey
Book Design: *the*BookDesigners
All photographs by John Storey except pages 8 (lower right),
16, 17, 26 (lower six), 29, 34, 36 (lower nine), 41 (middle left),
and 64 (Colleen Neff) and page 55 (Eliza O'Malley).

Orders, inquiries, and correspondence should be addressed to:
 Heyday
 P.O. Box 9145, Berkeley, CA 94709
 (510) 549-3564, Fax (510) 549-1889
 www.heydaybooks.com

Printed in East Peoria, IL by Versa Press Inc.

10 9 8 7 6 5 4 3 2 1

FSC
MIX
Paper from
responsible sources
FSC® C005010
www.fsc.org

For those who are holding the line, living Big Love, keeping Berkeley quirky and true to itself.

CONTENTS

INTRODUCTION

For those of you who are just joining the program, Quirky Berkeley was conceived in the critical care unit at Alta Bates Hospital in December 2011. I dodged a bullet named sepsis, and had the opportunity to look at my life and make changes.

One of the outward and physical manifestations of my inward epiphany was the launching of *Quirky Berkeley*. In late 2012, I started to walk every block of every street in Berkeley, cataloging and photographing quirky material culture (the physical evidence of a culture in the objects and architecture they make, or have made) that I could see from the sidewalk. I articulated precise rules about what could be included, rules which I followed for a time. I edged away from the rules though, cautiously at first and eventually with complete abandon. Douglas MacArthur said, "Rules are mostly made to be broken

and are too often for the lazy to hide behind." *J'agree.*

In 2013 I started to blog about what I was seeing. In 2014 *Berkeleyside* began running condensed versions of my blogs. It was because of Frances Dinkelspiel at *Berkeleyside* that I began to pay attention to the people behind the quirky material culture—the artists, the collectors, and the Berkeleyites (or is it Berkeleyans?) who make gifts to the street with quirky stuff in their lawns and gardens and porches. I settled into the role of Berkeley *flaneur*, an observer without an agenda.

Now five years into the project, I have not quite finished walking every block of every street. As William Hurt's character Nick Carlton says in *The Big Chill*, I'm not hung up on this completion thing. I still walk. I still find things. I still delight in the things and people I find. I'm in no hurry to finish. I'm still blogging strong.

In the last year, *Quirky Berkeley* took on a new feel. It started to feel like something that was here before me and will be here after me. It started to feel like I had not much to say about where it was going—it was going and I could follow or not. The number of coincidences emanating from *Quirky Berkeley* became too large to ignore. I couldn't help but feel that the trajectory had been chosen for me, not by me.

Look at the people and quirky work that I feature here—Conny Bleul (transplanted Berliner with her murals and painted furniture), Mike Nagamoto (retired firefighter with a welding torch and a saxophone-playing

rusting steel skeleton in his front yard), Olivia Hunter (retired hairdresser with her love of all things pink and purple), Dick and Beany Wezelman (lifelong lovers of Africa with African designs painted on their stucco house and an African mud hut in their backyard), Jos Sances and Robbin Légère Henderson (printer/artist and artist with their love for the Oakland A's proclaimed in bas-relief tiles on their roofline), Karl Wanaselja and Cate Leger (architects who work with highway signs, car parts, stripped bark, and shipping containers), Marcia Donahue (the spiritual center of Quirk Berkeley with her Notre-Dame of Berkeley gardens), Michael O'Malley (software genius, gadfly of the press, and maker of not-your-mother's pottery shown in his fence of doors), the home of Frank Moore (performance artist and shaman, now gone), stream restorer Riley and muralist Stefen (wraparound mural of little people and California native plants), Jane Norling (printer, graphic artist, and mural-ist and her originally-in-San-Francisco mural), and Mac McIlroy (former punk rocker, balancer of axial rocks, and creator of small worlds). Wow!

When I finished the first volume of *Quirky Berkeley*, I had more than enough major manifestations of quirk to fill this volume. Deviating from the first volume, here I intersperse quirkily decorated businesses with residen-tial quirk.

I have become acutely aware of how Berkeley is changing. The fact that the median home price in

Berkeley is north of $1 million means something. In May 2010, Patti Smith told students that New York was no longer the city for them. "New York has closed itself off to the young and struggling," she said. "New York City has been taken away from you." To some extent, this can be said of Berkeley. Many of the artists whose work I celebrate came to Berkeley in the late sixties and early seventies, young and struggling. They could afford to live here. Now, not so much.

Yes, change is inevitable. Berkeley has reinvented itself many times, and we will reinvent ourselves again. As I see today's manifestations of individualism and creativity, I think of the toga-wearing dancers at the Temple of the Wings one hundred years ago, of Chiura Obata's watercolors, of the bookstores and music stores and espresso stores and bakeries that made Telegraph our Boulevard Saint-Michel in the 1950s; I think of SLATE and the HUAC demonstrators and the FSM and the Vietnam Day Committee and People's Park; I think of the past and see today and feel that it is a single continuum, all one flow, like a stream—little eddies, little waterfalls—but the river continues.

I still see new quirk every day, in every part of Berkeley, despite the Equinoxing that is going on. When I tell people that I am photographing their lawn for *Quirky Berkeley*, often they smile—*they know about Quirky Berkeley!* Best ever, in the fall of 2017, I took visitors from Italy to Frederic Fierstein's Buddhist altar on Arch Street. A family was

there on a scavenger hunt devised from *Quirky Berkeley*—once you found the quirk, you were to grok it. How perfect! A big Quirky Berkeley word—to understand intuitively or by empathy.

The spirit of Berkeley is not easily extinguished. The big love and fun that are part of Quirky Berkeley are hard to resist. That which we love about Berkeley is at risk, but I have hope that our dear old Berkeley will not merely endure, it will prevail.

This book and my blog are all well and good, but the real joy is in discovery, in being a *flaneur* and walking our streets with an eye for the odd, whimsical, and quirky. It calls you. If you try, you will find it.

FOLK ART AND MURALS

CONNY BLEUL

1748 Marin Avenue and Berkeley Marina

Y ou have almost certainly seen Conny Bleul's trompe l'oeil Bambi garage door as you drive up Marin, just below Colusa. Bambi tricks the eye into perceiving a painted surface as a three-dimensional object.

Near the sidewalk in front of her house, there is a bench where a nicely dressed, very German-looking two-dimensional older couple sit. The bench Bleul found, cleaned up, reinforced, and painted in honor of her parents' fiftieth wedding anniversary. In the ivy above the bench are painted flat wooden ducks and pigs.

Bleul and her husband and first child moved to

Berkeley from Berlin in 2002. She thought that she was coming for eleven months, the projected length of a bio-tech assignment, based in Richmond, for her husband, Martin. She is still here, with her husband and now three children.

Bleul was born and raised in Berlin. As a university student, she took part in the mass demolition of the Berlin Wall in November 1989. On September 30 of the following year, Bleul ran the Berlin Marathon, which for the first time passed through East Berlin. She describes the feeling of running through the Brandenburg Gate from west to east as profoundly moving.

She was a world-class swimmer, swimming on the German national team, the 1984 German Olympic team

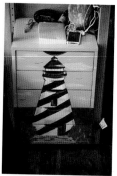

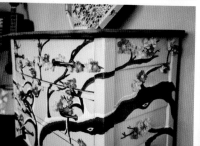

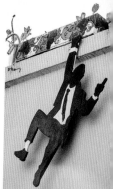

(injured so did not compete), and in Berkeley on the Aquatic Masters team. She has a Ph.D. in philosophy, has worked as teacher for going-on thirty years, and earned a degree in museum studies at USF. When she left Berlin to come to Berkeley, she was a teacher at a public school, a university professor, and aquatic sports director at the Free University of Berlin. Now she is the director of the German School of the East Bay. She is also a well-known and highly respected birth doula, giving assistance and advice to new and expectant mothers.

I don't know about you, but right about now I am starting to feel lazy and unaccomplished.

And to the point here, she is a self-taught artist, an autodidact. After getting her doctorate in philosophy

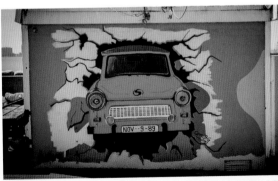

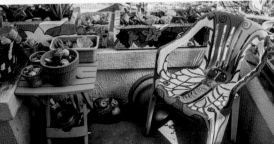

from the Free University of Berlin, Bleul expressed an interest in going to art school. Her parents were pragmatists and saw no economically viable path forward in art. No art school for Conny in Berlin. But here it was a different story. She started painting and didn't look back. "If you're interested in art, you can't suppress it. It will come out," she says. It came out.

When she took up windsurfing (of course), she got to know the guys at the Cal Sailing Club. She convinced them and they convinced her that the shacks and storage containers at their spot on the Marina were destined to be her canvas.

Her murals there are an eclectic mix of styles—Pop, Banksy, Disney, graf. My favorite: a tribute to a famous mural in East Berlin from the time of the Berlin Wall's collapse, which depicts a Trabant sedan bursting through

the wall. The original Trabant mural was painted by Birgit Kinder in 1989 and still stands as part of the East Side Gallery, a stretch of wall left standing near Berlin Ostbahnhof, a train station.

Bleul loved Berkeley from the start. She arrived just before Christmas and was struck by all the Christmas decorations and by the people of Berkeley buying Christmas trees in shorts and T-shirts. She loves Berkeley still, but feels that it is busier and more crowded and, um, more developed. She isn't happy with the number of chains—Walgreens and Starbucks and Nike. "Berkeley isn't so quirky anymore," she says.

This is the Berkeley that I love though, the Berkeley where a woman like Bleul would come for a few months and stay for decades, bringing her art and creativity and zest for life here.

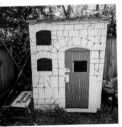
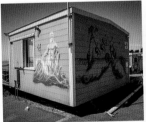
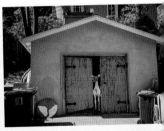
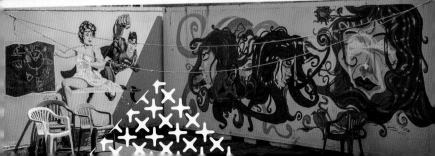

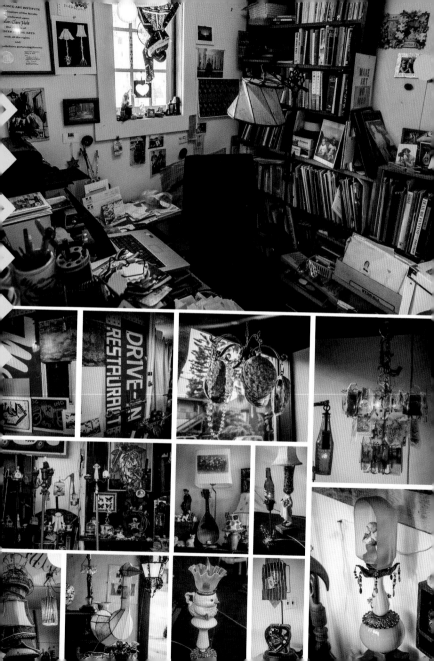

HELLY WELLY LAMPS
AND LIGHTING DESIGN

HELEN HOLT

1649 Dwight Way

Helen Holt moved to Berkeley as a child, coming from London via Rhode Island. She grew up here, daughter of UC Berkeley professor of aerodynamics Maurice Holt. She has lived on Dwight since 1979. She raised her two daughters here, in what had been Sherwood's Antiques, and before that a butcher shop.

To say that Helen Holt makes lamps is true but it is a truth that masks the truth. She makes art, and some of the art is lamps. Her business is Helly Welly, a childhood nickname endowed upon her by her late brother Nick.

The shop/gallery/home is full. It is impossible for the eye to take in all that is here, but here are some photos that give a sense of the genius that lies in the shop. There are Mark Bulwinkle prints from his time at the San Francisco Art Institute—Holt attended at the same time. There is the Mel's Drive-In sign from Shattuck. But most of the work is Holt's. It is made from bric-a-brac, knickknacks, trinkets, gewgaws, gimcracks, tchotchkes, bits and pieces, odds and ends, things, stuff, junk, kitsch. It defies description. It begs for photos. It is as quirky as quirky can be.

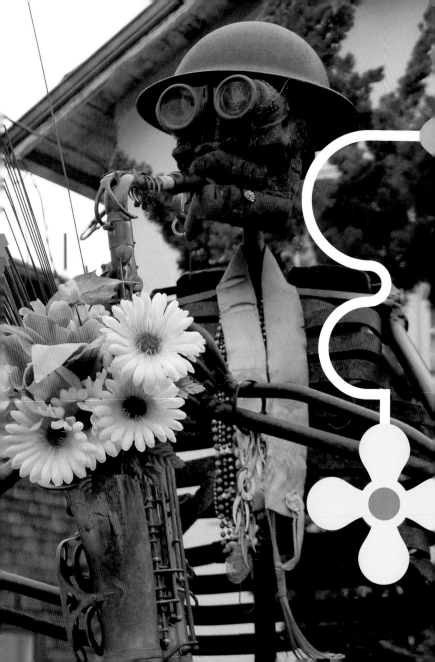

RUSTY SKELETON PLAYING THE SAX

MIKE NAGAMOTO

2219 Marin Avenue

"I'm the welder."

That's what Mike Nagamoto said when Berkeley *flaneuse* Colleen Neff and I knocked on his door and asked if he was the artist who made the rusting saxophone-playing steel skeleton in the front yard of his house. Nagamoto identifies first with his craft and secondly with the art that is the result of his craft.

If Quirky Berkeley were to grant Quirky Landmark Status, the rusting steel skeleton playing a saxophone would be a first-ballot and unanimous choice. It is prominent, quirky, and because it is on a well-traveled street, it is known by many.

The sax-playing skeleton is the centerpiece of the work in his front yard. This is not the first skeleton to stand in the yard. The original sax player was stolen in the late eighties. Bad karma! Bad thief! This one is big and heavy and attached to big and heavy things. It will not be easily stolen.

The front yard is filled with pieces that Nagamoto has made, filled to the point that his wife has suggested that no more art go in the front yard. To be fair, there *are* a lot of steel fish. There are also balanced rocks. They might be termed axial stones, and they might be stabilized by internal rebar. And waste not, want not—Nagamoto cut empty welding-gas tanks and used them to fashion large wind chimes. Very large.

Nagamoto retired from the Berkeley Fire Department, with thirty years of service, in 2008. He has also worked as an industrial welder under contract with Pile Drivers, Divers, Carpenters, Bridge Wharf and Dock Builders Local 34, taught welding at Laney, and taught welding in PG&E's PowerPathway program.

He loves welding and scuba diving and staghorn ferns. He is a practicing Buddhist, and some of his steel work is for sale at the Buddhist Churches of America's bookstore at 2140 Durant Avenue.

What a prince of Berkeley quirk Nagamoto is. A self-effacing, humble, bemused retired firefighter, a welder, a diver, a lover of ferns—and an artist who welds, a welder who arts. The skeleton is a Quirky Berkeley Landmark, and so is Nagamoto.

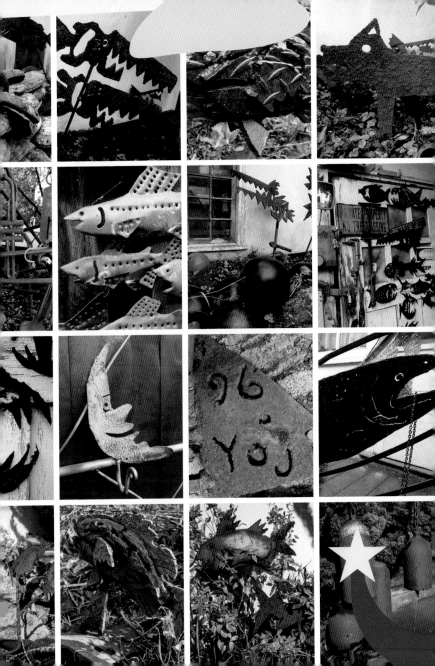

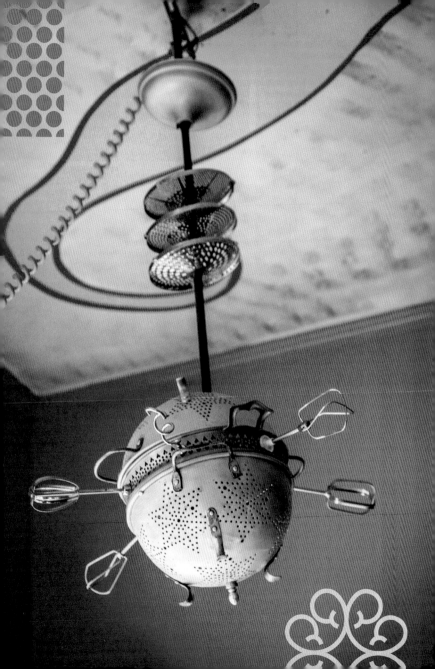

PANACHE LIGHTING

JANA OLSON

2743 Ninth Street

On July 6, 1971, Olson came to Berkeley from Minnesota looking for work in landscape architecture. She got a job quickly. And stayed.

In the nineties, she took over Omega Lighting on San Pablo, not to be confused with Ohmega Salvage on San Pablo. She got good at rewiring and repairing lamps.

The relationship that was the basis for Olson's work at Omega ended as did her time at Omega. She married Roger Carr, a Burning Man artist and physicist at the Stanford Linear Accelerator Center. In 2006 he walked away from Stanford and she walked away from Omega. They started a whole new deal. They were too young to call it an encore career move. Just—starting a whole new deal.

Her part of the whole new deal was lighting. She had the idea of making lamps a long time ago, but it took a while to take the idea from concept to reality, that reality being Panache Lighting on Ninth Street. *Panache?* Flamboyant confidence of style or manner.

She repairs and fabricates lamps. Her lamps are not your grandmother's lamps. She is fond of everyday objects repurposed as lamps—kitchen utensils and teapots and Wedgwood porcelain cups, Lusterware, and old French horns. And there are thread spool candlesticks!

And you should see the shadows that the table lamps made with colanders cast when it is dark!

Yes, people like Olson are found outside Berkeley. But she's here. And only here. And there are more like her, what Mark Bulwinkle calls "aesthetic conspirators." She and they make this a better place, a special place, a creative place. Sculptor Doug Heine says "She is a treasure and a reminder of why I live in Berkeley." I second that assessment.

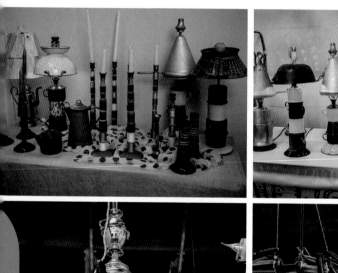

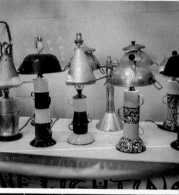

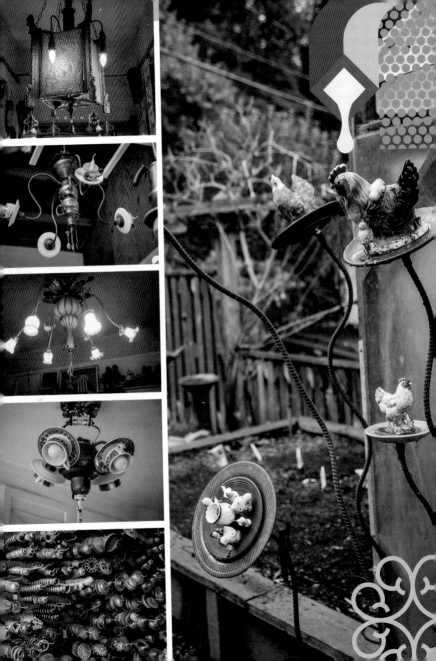

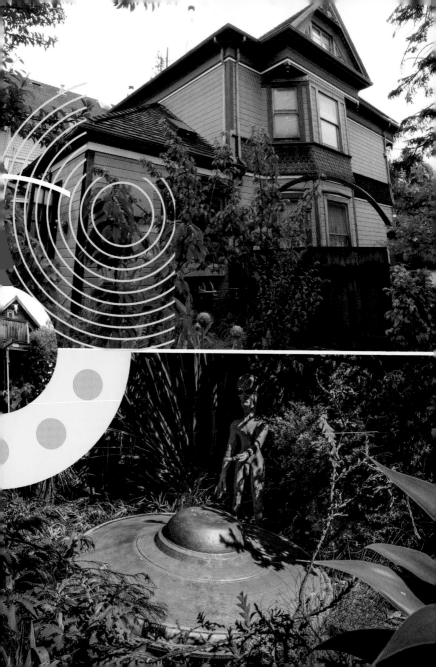

UFO AND ALIEN—BERKELEY OR BUST
GEORGE MCNEIL
AND JOANNA SALSKA MCNEIL

2150 Vine Street

On April 1, 1966, Alfred Peet opened the first Peet's Coffee & Tea store on the southwest corner of Walnut and Vine. The artisan coffee movement was underway in what would soon be the Gourmet Ghetto.

Almost fifty years later, a flying saucer with a "Berkeley or Bust" bumper sticker and an alien appeared in a front yard half a block east of Peet's. It has been suggested that the alien came not to abduct (no trailer park nearby anyway) and not to probe, but because of Peet's small batches, fresh beans, superior quality, and the rich and complex dark roast.

While this may be so, I have been told by George McNeil

and Joanna Salska McNeil that Kyle Milligan, an Oakland artist, made the saucer and gifted it to them. Milligan's large works are described as funny and uneasy, layered with meaning, both acute and obtuse. Dig that terminology!

The McNeils have lived in the Vine Street house for about twenty-five years. It was built in 1895 and had been vacant for years when they bought it. They took it from collapsing and neglected to lovely and bright and— quirky. The three cutout cats on the second floor were random finds at a flea market. Simple as that.

The front yard—a planned and well-executed jungle— is filled with quirky objects. There is a fire hydrant found abandoned on the side of the street when Oakland's Preservation Park was under construction. There are marine fixtures—cleats and bollards and a winch with rope. And there is art, much of which was discovered at the Alameda Point flea market.

Joanna, a native Pole, is an artist of acclaim and talent. She painted the house. Herself. Pay attention to the colors—really stunning. Her art hangs everywhere inside. Shortly after they moved in and got the roof back on, Joanna painted a mural in the dining room, evoking a bucolic Poland. She says that her creation was informed by arras, or tapestries. To pay the bills she does construction jobs, home remodels.

George is a longtime member of Pile Drivers Local 34 in Oakland. He works in marine—underwater—construction. These days he is a diver tender—let the younger men and

women dive! George is curious and inventive. He is the one who loves flea markets. He has a collection of *National Geographic* magazines dating back to 1905. He loves it. He reads them. He consults them. George brings home things that amuse him. He has a collection of shoeshine boxes with footrests. He has a railcar mover, with which a person can validate Archimedes and move a railcar manually. He has a device that was used to sharpen razor blades.

The house on Vine Street is an old house with lots of angles and lots of dormers and pitches. George has built several hidey-holes, secret spots for kids to play, and also a sleeping nest—this was when he was working night shifts and needed a snug spot to sleep.

In the backyard, the main event is a tree house. It is big enough for a person to sleep in it. Persons have slept in it. Hanging from the tree house is a giant monkey's fist knot. The monkey's fist knot is most often used as the weight in a heaving line.

What is not to love about this house and this family? A union construction worker and an artist who also does construction work buy a completely beat-up old house and make it beautiful. She makes art. He is part of the boom-and-bust construction world. He loves *National Geographic* and hidey-holes. No wonder, I say, that the UFO chose this yard in front of this house. The alien wanted to see the best that Berkeley has to offer—within throwing distance of the original Peet's.

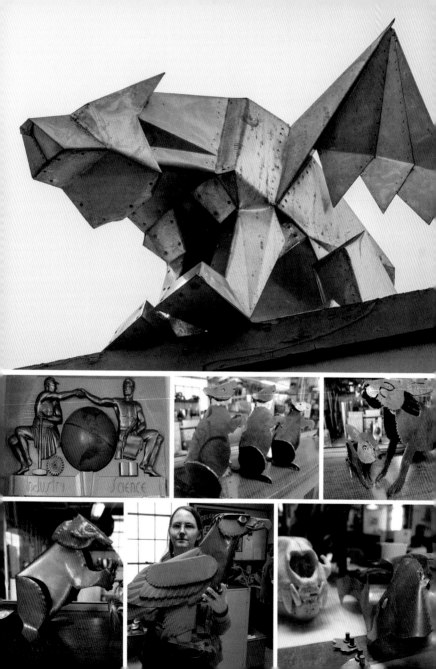

WALTER MORK CO.

MELISSA MORK

2418 Sixth Street

Melissa Mork is the daughter of Fred Mork who is the son of Walter Mork Jr. who was the son of Walter Mork Sr. Walter Sr. came to Berkeley after the 1906 San Francisco earthquake and in 1909 started the business that is today Walter Mork Co., which handles heating, cooling, and sheet metal fabrication.

Mork was a Finn, and an important player in Berkeley's Finnish community, a small but disproportionately influential population in Berkeley. Walter Mork was involved in building both the Finnish Hall on Tenth Street, built by the radical Finnish Comrades' Association in 1909, and the less radical Finnish Hall on Chestnut, built in the 1930s. Melissa Mork remains involved with the United Finnish Kaleva Brothers and Sisters Lodge 21 on Chestnut.

Melissa grew up around the shop. Her father taught sheet metal theory and skills. She then took it away from HVAC and functional fabrication into art. She has an extraordinary knack for sheet metal origami—visualizing a three-dimensional creature, mapping it onto a piece of sheet metal, and then—fabricating.

Her most prominent works are the gargoyles on the roof of Walter Mork Co.—although the term *gargoyle*

is not technically correct, as there is no rainwater redirection involved, an essential duty of a full-blooded gargoyle. In architecture the term *grotesque* means a carved stone figure. Grotesques are often confused with gargoyles, but grotesques do not contain a waterspout through the mouth.

These grotesques have another function. Tinsmiths and sheet metal workers have made tin men to serve as three-dimensional shop signs for centuries; these ones are just perched on the roof. Inside the office a number of smaller sheet metal origami pieces made by Melissa are for sale. There is often a work in progress, and you can see how Mork starts flat and goes 3-D. The grotesques rock old-school tinsmith quirky. The smaller pieces— quirky too.

QUIRKIEST GARDEN EVER
MARCIA DONAHUE
3017 Wheeler Street

I have a number of rules that guide my Quirky Berkeley quest. I have a number of rules that govern inclusion in this volume. I routinely ignore or overrule my rules for my blog, and I am here and now, with you as my witness, violating my cardinal rule of not repeating here any artists featured in the first volume.

I wrote about Marcia Donahue, telling you that she is the spiritual center of Quirky Berkeley (everyone knows her and she knows everyone) and showing you the stone and clay sculpture that you will find in her Wheeler

Street backyard.

Here I focus on the garden.

When Donahue was eight, her family moved from Urbana, Illinois (where my grandmother, Dami, was born!), to San Anselmo. She remembers being impressed at an early age with the Japanese Tea Garden in Golden Gate Park. Her mother taught her the names of plants and gardened. Donahue remembers, "I had a little garden when I was in grade school where I grew plants that Sunnyside Nursery threw out."

Donahue moved to Berkeley in 1976 for an M.F.A. program. She and her former husband bought the house on Wheeler in 1978. She describes her odyssey: "I was lured out of my studio and into the backyard. I started digging and planting, reading horticulture and garden history, visiting gardens, gardeners, and nurseries, including

the famed and fabulous Western Hills in Occidental. I began working as a gardener for other people and joined Jana Olson's little landscape company."

Her garden is the result of almost forty years of creative and innovative gardening. Of it, she says, "For me, gardening and making sculpture are the same work/play/improvisation. The garden is such a generous collaborator. It never stops surprising me, always changing, frequently thrilling me. The Berkeley climate permits year-round gardening, suits a large variety of exquisite plants, and lets a lot of experimentation succeed. Fellow gardeners here share plants, information, and enthusiasm freely. I feel very lucky to be doing this."

For me, her garden is the Notre-Dame of Berkeley. It is a place to be calm and inspired. She opens her garden to the public Sunday afternoons. If I were you, I'd go.

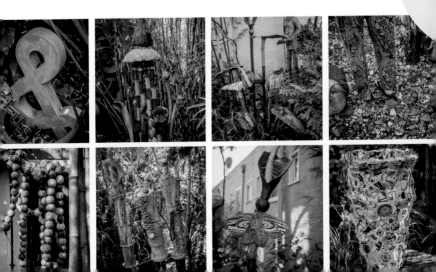

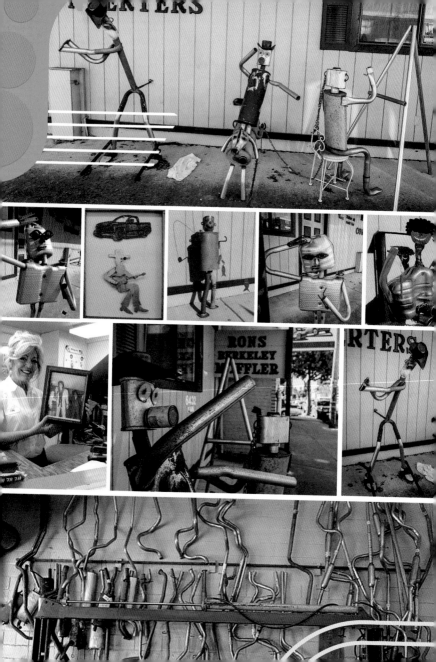

RON'S BERKELEY MUFFLER
RON HULSE
6432 Shattuck Avenue

Ron Hulse and his wife, Deanna, opened Ron's Berkeley Muffler at 2420 Shattuck Avenue in 1962. In 1989 they moved to a new spot and then eventually to 6432 Shattuck, "just inside Oakland" as the business card says. In other words—not in Berkeley. Rules are made to be broken—Berkeley is in the name and the muffler men are hella quirky. They're in!

Muffler shops have a heritage of "muffler men," figures constructed from discarded automobile mufflers. The muffler men are a way for apprentices to hone skills and for journeymen to pass time when there are no jobs. Over the years, Ron and his mechanics made muffler men, which he displayed outside the shop. Over the same years, theft (bad karma!), purchase, and give-away (good karma!) have culled the herd.

The Hulses' daughter Abby Mayes runs the shop today. She is inspired by the interest in the muffler men. In 2015 she gave the crew the green light to "get creative" with muffler sculpture during downtime in the shop.

Check them out. If you have a minute, stop in the shop and meet Abby. Ask her about Elvis and ask her about Billy Ray Cyrus. Cool stories and photographs await.

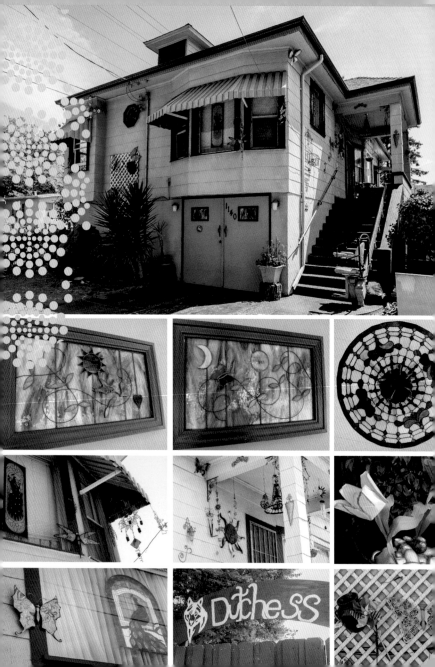

PINK AND PURPLE BUTTERFLIES

OLIVIA HUNTER

1140 Bancroft Way

Olivia "Cookie" Hunter always wanted to paint her house purple. She has gotten halfway there—purple trim.

Hunter is a retired hair stylist who grew up in this house with her grandparents living next door. She remembers a happy childhood surrounded by family, the overflowing hippie scene in Berkeley, and the fun and excitement of the Black Panther Party's community-based service programs. These were heady years for the Panthers—before Huey Newton got arrested and Little Bobby Hutton got killed by the police and the full

weight of the government proved in a few short years just how futile armed resistance is. But those years, when the Panthers were full of hope and when the Panthers and the student left were aligned—that is the Berkeley that Hunter knew and loved as a teenager.

Hunter announced her hope of painting the house purple when her mother was still alive; her mother disapproved, and made sure that neighbors reminded Olivia of her disapproval after she had passed away. The violet trim with pink accents is a compromise, reflecting Hunter's love of all things pink and purple, an outlet for her artistic creativity that had been mostly shown in her hairstyling. This goes a long way toward explaining the pink barber chair on the porch.

Along with the purple and pink trim, the house is adorned with butterflies and dragonflies and peacocks and owls and stained glass and rainbows and wind chimes, lots of wind chimes. There is pride and vision and individuality in this house.

At the base of the stairs to the front porch is a pot of gold. Hunter's grandparents—or was it her great-grandparents?—hauled a washtub for thousands of miles as they worked their way to California, hoping that California would be the land of plenty. It has been the land of plenty for Hunter, and so she painted rocks gold to honor the courage and foresight of her family.

Neighbors and passersby stop and chat with Hunter.

She is an extrovert and greets strangers and people she's known her whole life with the same warmth. For the twenty minutes we sat on her porch talking, she probably greeted at least five people walking past—by name, with a smile.

Hunter's quirk is unlike most of the quirk that I present, but the quirky in Quirky Berkeley is big-tent. There is room for purple and pink trim, butterflies and rainbows, and a pot of gold.

LANESPLITTER PIZZA

DANIEL ROGERS AND VIC GUMPER

2033 San Pablo Avenue

L anesplitter on San Pablo is a beer pub. It's a pizza joint. There are vintage motorcycles hanging from the ceiling. And—quirky action figure dioramas depicting Lanesplitter employees, past and present.

Daniel Rogers and Vic Gumper bonded while attending Cornell University's School of Hotel Administration. They worked at Bison Brewing together, quit together in 1996, and opened Lanesplitter together in 1998.

There were action figure/doll displays almost immediately. They fill the walls.

There is a one-page explanation of the dolls toward the back of the restaurant, signed by Scott and Madeline, Vince and Erica, dated May 2007.

The owners were struck by the people they hired to work there. "Soon we were imagining everybody at Lanesplitter as a doll, as 'action figures' with accessories and clothes and packing—the works." Priding themselves on being "the kind of people who can talk each other into doing just about anything," they decided to actually make them.

The first dolls went on display in 1998. There were "more cool people and more dolls," and they continued

making "quirky, silly dolls to honor Lanesplitter" until at least 2007.

So there it is! Dolls to honor individuality. Dolls to honor community. Dolls and the adjective *quirky*. What more could a *flaneur* want?

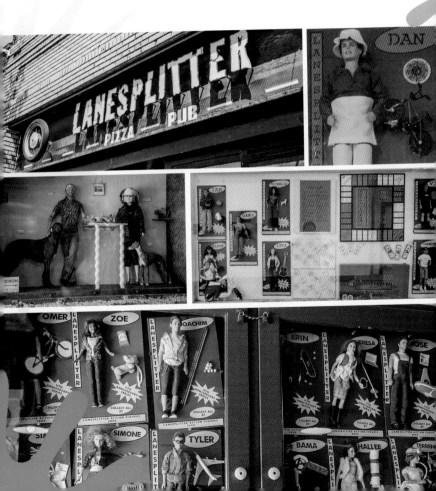

AFRICAN DESIGN AND MUD HUT
DICK AND BEANY WEZELMAN
1026 Shattuck Avenue

The Quirky Berkeley rules of engagement are clear and unambiguous. One of the rules is that the material presented must be "visible from the street, alley or path." I break that rule with some regularity on my blog, but have not on the printed page. Until now. Right now. Here.

On the residential section of Shattuck Avenue north of Rose Street, in the block before Los Angeles, you come to a block of Big Houses. Stately houses. And you come to a stucco house with African-themed designs.

This is the home of Dick and Beany Wezelman, natives of Chicago. Beany got her M.A. at Cal in 1964,

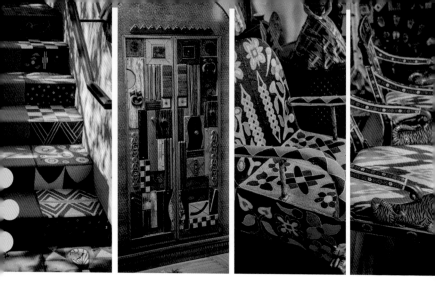

majoring in political science with an African specialty. Later that year, she joined the Peace Corps and was sent to Ethiopia. Dick came to see her. They married in Dar Es Salaam in 1966. In 1971 Dick and Beany moved back to Berkeley and started annual trips to Africa. They have been collecting and selling African art since then.

Africa was in their blood. They hitchhiked across the Sahara in 1973. Yes, that's what I said. Hitchhiked across the Sahara. The walls of their home are covered with photographs of them with different tribes—Tuareg (Berber people, nomads in the Saharan interior of North Africa), Himba (the last seminomadic people of Namibia), and the San people, also known as Bushmen, members of different hunter-gatherer peoples of Southern Africa.

The house is covered with painted African designs. The garage and basement doors and the paintings on

the front of the house above the windows were done by Lee Orr, an artist who now lives in Hawai'i. Everything else was done by across-the-street neighbor Bill Fulton.

The geometric designs on the garage and basement doors are taken from house paintings of the Soninke people of Mauritania, as are the designs on the front of the house. The geometric designs on the north side of the house are from Ndebele house paintings, like those found in South Africa, and the image on the north side of the house is a Senufo fertility figure. The Senufo live

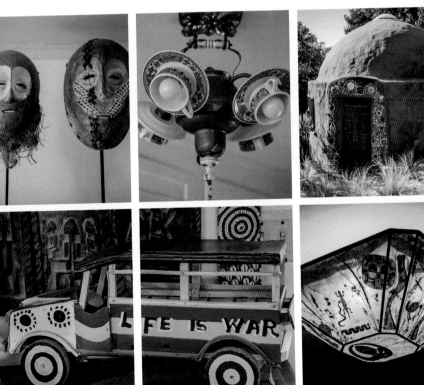

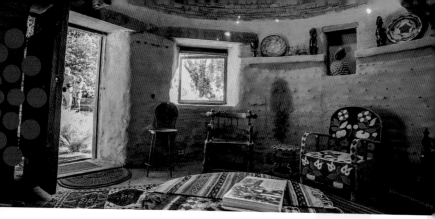

in the northern part of Ivory Coast.

The large animal you see crawling across the front of the house is a stylized gecko. Geckos are revered animals in many West African societies as they are believed to be one of the earliest creatures on the earth. As you climb the front steps, you are greeted by a figure from Senufo tapestries. And the paintings next to the front door are stylized African designs—the cowry shells being important in African jewelry and a former currency, and serpents being another revered animal.

The paintings going up the front stairs are an assortment of African designs. The railing you held on the way up is the work of Mark Bulwinkle. Bulwinkle traded his work for carved colons. A colon is a wooden sculpture that originated during the colonial period. They depict European colonial officials or Europeanized Africans.

And finally—the African mud hut in the backyard. You can't see from the street, alley, or path, a fact that breaks the fundamental rules of Quirky Berkeley. The

Wezelmans liked traditional mud huts in Ghana. They wanted one in their backyard. In 1992 they turned to Peter Rudy, an arborist with a knack for a lot of things besides trees. He wanted to build with adobe. Bingo!

He made adobe bricks in the general vicinity of Livermore. And they started to build. There is some concrete, and some rebar—which you won't find in the construction of a typical African mud hut. By the time you get up to the dome, it is all adobe bricks. No rebar there. The door is from Mali. It is a Dogon granary door. The Dogon people are known for their intricate carved doors, screens, and panels.

In August 1992, the Wezelmans and Rudy celebrated the completion of the hut. Rudy and his about-to-be-wife surprised the group by getting married. On the spot. No warning. Still married!

And the hut—wow!—still there.

Also in the backyard near the hut is a Mark Olivier beach trash sculpture. In the front yard, a flat stone Marcia Donahue sculpture. In the kitchen, a Jana Olson teacup ceiling lamp.

Meaning—all Quirky Berkeley roads lead to the Wezelmans on Shattuck.

They are a remarkable couple. The courage and sense of adventure that led them to hitchhike through the Sahara, and their lifelong love of Africa are present, very present, as they age.

PRECISION PEOPLES CAR REPAIR

KEN SHAPIRO

1346 San Pablo Avenue

Once upon a time, a skinny young man with long curly hair, an FAA mechanic certification, and a couple years' experience at the Boston Volkswagen dealership drove from Boston to Berkeley in a 1958 VW beetle via lots of places including Oaxaca—one of those young and wild drives all night across the continent that some of us knew in the sixties and seventies—and shortly after arriving opened a garage that is going strong forty-six years later.

Ken Shapiro, who owns and runs Precision Peoples Car Repair on San Pablo, is a reminder of a Berkeley that is slipping away, when the young and struggling could come here, start a business, buy a house, make a life with room in the margins for quirky things.

What quirky things? Well, remote control airplanes hanging from the ceiling, lots of them. Big ones. Shapiro flew his first remote control model plane in the late seventies. He has many planes. The air above the floor of the garage at Precision Peoples Car Repair is filled with planes. A back room on the main floor is filled with planes. The storage area on the mezzanine is filled with planes.

Shapiro exudes joy and enthusiasm. The planes are joyful. Quirkily joyful.

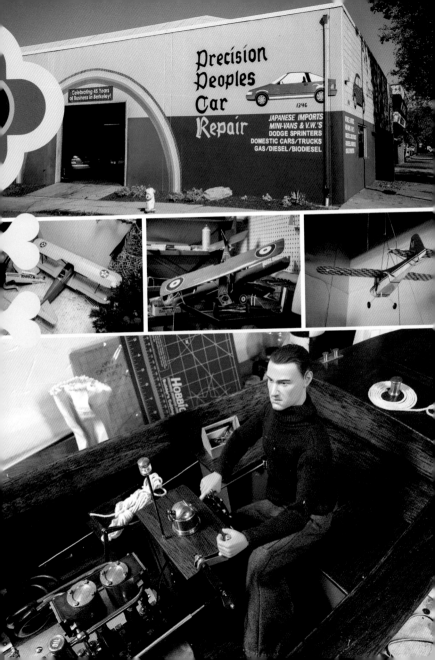

ARTISANAL RECYCLED ARCHITECTURAL QUIRK
KARL WANASELJA AND CATE LEGER
2434 Martin Luther King Jr. Way and 2322 McGee Avenue

The architecture and materials used in the nine-unit building on the northwest corner of Dwight Way and Martin Luther King Jr. Way are, in and of themselves, valid admission to the World of Quirk.

At first glance, this is a fairly conventional structure. First glances lie. The building seems to be sided with aluminum plates, but then you look up under the carbuncular bay windows and you see that those plates are in fact recycled highway signs. And you see that the awnings are what used to be Mazda and Porsche hatchback windows. And that the gates are made with rear

ends of eight Volvos and recycled street signs.

Architects Karl Wanaselja and Cate Leger designed this building. They are nothing if not geniuses when it comes to repurposing the spoils of junkyards, and doing so with flash and flair. Karl is especially big on recycling car parts, born perhaps of his parents' passion for amateur car racing. He estimates that he has used parts from two hundred and fifty cars in seven different projects.

Their house a few blocks away on McGee is sided with salvaged gray car roofs and poplar bark, which otherwise would have been discarded as a waste product by a North Carolina lumber mill. The awnings are fabricated from car windows, the Dodge "best-selling minivan" Caravan to be specific.

Their studio behind the house: insulated salvaged shipping containers placed in an L shape.

Leger and Wanaselja practice green design, shrinking the ecological footprint of the project by relying on repurposed materials. That is all good and well, but the design is what brings them to these pages. Architects may come and architects may go and never change your point of view, but these two with their artisanal recycling make you sit up and shout "Quirky!"

OHMEGA SALVAGE
KATHERINE DAVIS
2403 San Pablo Avenue

The gate to Ohmega Salvage is dominated by two huge joyous women ceramic statues. Made by Leslie Safarik and formerly owned by Danielle Steel, they welcome visitors, along with an early 1950s Willys Jeep Wagon.

Ohmega Salvage came into being in 1974 when Victor "Vito" Lab and Bob Ford deconstructed a large building at Oakland's naval supply center, recycling thousands of board feet of lumber, which they sold to DIYers and architects.

Ohmega initially bounced around in South San Francisco and San Francisco until moving to Berkeley. There was a big hippie vibe, and counterculture icons such as Wavy Gravy and John Fogerty were friends and customers. Vito Lab believed in Gaia theory, that organisms interact with their inorganic surroundings on Earth to form a synergistic self-regulating, complex system that helps to maintain and perpetuate the conditions for life on the planet.

In 1986 Steve Drobinsky purchased the business from Vito and continued the tradition of salvaging architectural materials. He died in 2012, after which his wife,

Katherine Davis, took over the business.

Ohmega sells bath and plumbing fixtures, decorative accessories, architectural elements, chalk paint, doors, fireplace mantels, furniture, hardware, industrial and vintage oddities, ironwork, gates, lighting, ornamental plaster, and windows and glass. It is mostly the industrial and vintage oddities that rock quirky, and here is where the greatest opportunity for DIY quirk is to be found.

When I see the "oddities" at Ohmega, I imagine a room, a big room, with a lot of them, and with art from quirky artists. A room to celebrate creativity and quirkiness. A gallery? An incubator (whatever that is)? Why not? Where? I don't know. How? I don't know. But it would be great.

Room or no room, Ohmega is PERFECT for DIY quirk.

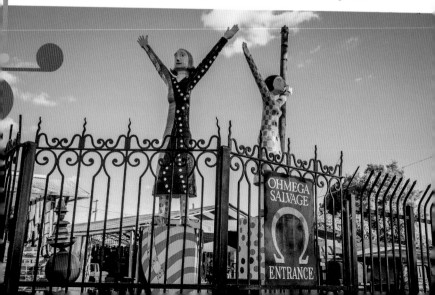

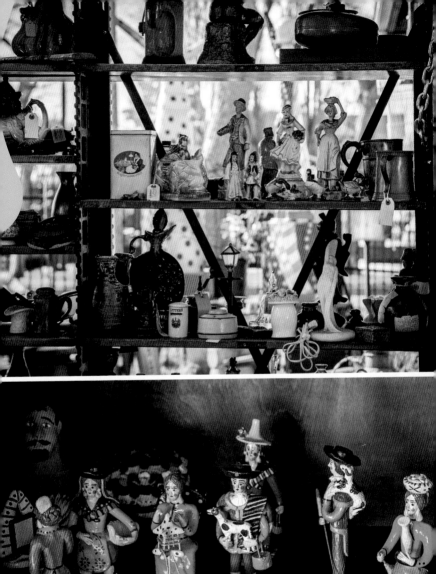
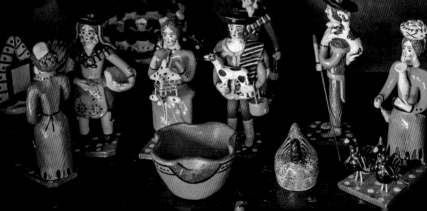

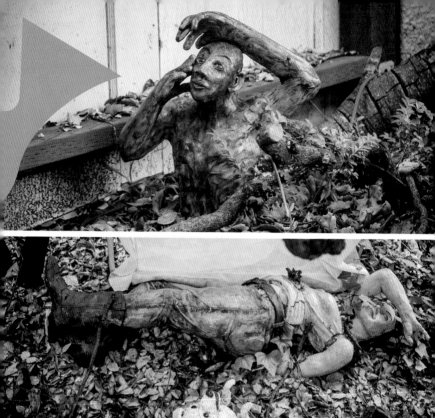

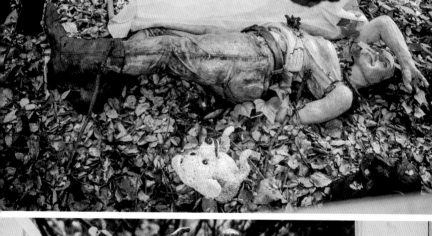

FENCE OF DOORS
MICHAEL O'MALLEY
2910 Ashby Avenue

Rachel O'Malley wrote me and suggested that I check out the fence of doors at the home of her parents, Michael and Becky O'Malley, who have lived on Ashby Avenue since 1973. I had walked Ashby in early 2013 and knew of no fence of doors and saw no sculptures.

What happened was that in the fall of 2013, the O'Malleys decided to build a fence to keep their dog in the yard. They decided that they didn't want fresh lumber. They wanted to use recycled materials.

They went to Urban Ore. They saw the sign that says "Old Doors Make Good Fences" and were intrigued. They hooked with up Urban Ore's Max Bechtel and together they designed a door fence. Max came to their

place and saw sculptures. He suggested that they use the fence of doors to showcase them.

That was it. A fence of doors displaying sculpture behind glass set in the doors.

The O'Malley names are well known in Berkeley. In 2003 they began publishing the *Berkeley Daily Planet*. Michael was listed as publisher, and Becky as executive editor. Under their guidance, the paper won a number of awards from the California Newspaper Publishers Association and other organizations, including first prizes for its opinion page, which publishes lengthy reader-written commentaries, and the editorial cartoons of Justin DeFreitas. Becky is known for her years of political activism, and Michael for a career in software, specializing in text-to-speech conversion technology.

It turns out Michael is also an artist. The sculptures are his, but he doesn't sell them—he just makes them. His ceramics are not in the "pots for mommy" school. They are bold and at times frightening. There is a lying woman—originally a standing woman—brought down by gravity and rain, Lilith and Eve (Knowledge and Innocence), Europa and Zeus disguised as a bull, and more.

The fence of doors is quirky on its face. Throw in its placement along the Big-House corridor of upper Ashby—even more quirky. Throw in the sculptures, quirkier still. I am glad that Rachel sent me here.

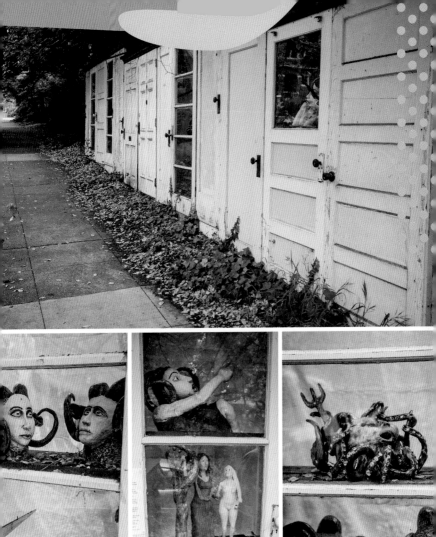
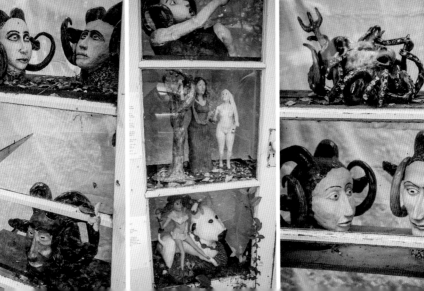

URBAN ORE

DANIEL KNAPP
AND MARY LOU VAN DEVENTER

900 Murray Street

Urban Ore is a gold mine of quirk. Its purpose is printed on every receipt—To End the Age of Waste. Daniel Knapp and Mary Lou Van Deventer started Urban Ore in 1980, recovering and trading resources from the City of Berkeley's landfill. Scavengers with a mission! It has grown, evolved, and moved. Reuse! Recyle!

The long rows of toilets and doors and sinks in the Building Materials Department are not without their quirky charm, but they are not the point of this exercise. The point: the mostly big, quirky stuff in the Salvaging and Recycling Department. Some may be for sale, some not. Instant DIY quirky though. Three acres under the roof—many, many things to find.

Knapp and Van Deventer are approaching retirement and are actively exploring the option of transferring ownership of the warehouse and business to their thirty-eight employees. Project Equity, a nonprofit that helps companies move to employee ownership, is helping.

As things stand, Urban Ore is one of our great treasures. A friend refers to it as "Berkeley's quirky props department." That's spot-on, and quite the accolade.

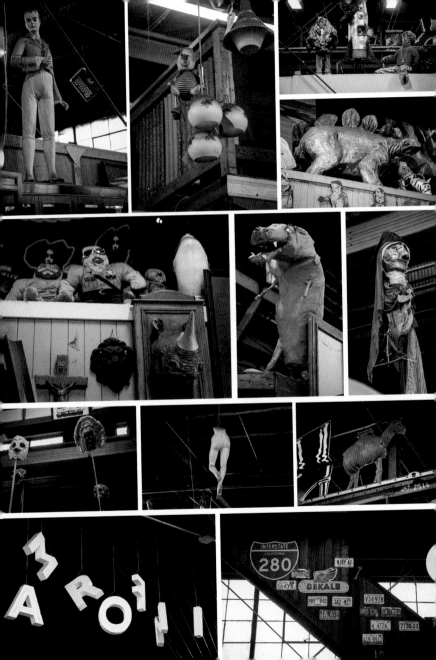

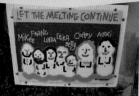

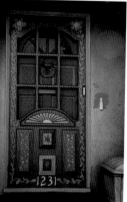

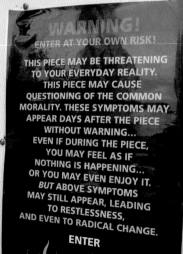

THE CHEROTIC rEVOLUTIONARY $5

WARNING
ENTER AT YOUR OWN RISK!

This piece may be threatening to your everyday reality.

This piece may cause questioning of the common morality.

These symptoms may appear days after the piece without warning ... even if during the piece, you may feel as if nothing is happening or you may even enjoy it. BUT above symptoms may still appear, leading to restlessness, and even to radical change.

FRANK MOORE

WARNING!
ENTER AT YOUR OWN RISK!

THIS PIECE MAY BE THREATENING TO YOUR EVERYDAY REALITY. THIS PIECE MAY CAUSE QUESTIONING OF THE COMMON MORALITY. THESE SYMPTOMS MAY APPEAR DAYS AFTER THE PIECE WITHOUT WARNING... EVEN IF DURING THE PIECE, YOU MAY FEEL AS IF NOTHING IS HAPPENING... OR YOU MAY EVEN ENJOY IT. BUT ABOVE SYMPTOMS MAY STILL APPEAR, LEADING TO RESTLESSNESS, AND EVEN TO RADICAL CHANGE.

ENTER

FRANK MOORE HOUSE

MIKEE LABASH AND LINDA MAC

1231 Curtis Street

The front yard shouts quirk. Tie-dye signs, naïve/ kids' art, peace signs, bright colors, and bubble letters. What is going on here?

Mikee LaBash and Linda Mac answered the door, which currently is leading the pack for the coolest door in Berkeley. Frank Moore lived in the house until his death in 2013, and they stayed on.

Moore had a severe case of cerebral palsy, a group of permanent movement disorders. He could not walk or talk. Cerebral palsy's chains drove Moore to nearly pure freedom, to pursue what he called "nonrational,

nonlogical, nonlinear magical knowledge." He declined to be confined or defined. He wrote that his chains were his salvation: "It was just my luck to be born into the long tradition of the deformed shaman, the wounded healer, the blind prophet, the club-footed 'idiot' court jester." Those words, *shaman* and *performance artist*, don't do justice. Forget the not walking and not talking—he wrote many books, directed plays and films, gave poetry readings, played piano, sang, and painted.

Moore moved to Berkeley in 1975, hoping to form a "tribal body" built on a group marriage. The "tribal body" in Berkeley eventually included Moore, Mac, LaBash, and three others, Corey Nicholl, Alexi Malenky, and Erika Shaver-Nelson. They evolved into two houses on Curtis Street, the Purple House (1231) and the Blue House (1200).

Mac grew up in Philadelphia. She went to Penn State and in 1974 came to Berkeley, where she found a job at a travel agency. She was in a holding pattern, she says, hanging, waiting for her life. She met Moore and they teamed up.

Mikee LaBash was born in Indiana, raised in Sydney, Australia, and returned to Indiana to attend Indiana University, where he got his B.F.A. In the eighties, he worked as a graphic designer in San Francisco. He was the lead singer and songwriter for the band Mr. Dog.

LaBash attended a Frank Moore performance at Rather Ripped Records in Berkeley, where Frank had naked body-painted dancers swirling around him with strobe lights

flashing and fog machines and LaBash thought, "This guy knows how to have fun with his art!" A few weeks later, Mikee quit the band. He joined the team.

They soldier on after Moore's death, preserving and cataloging his work, going to their day jobs. The house and studio behind the house are filled with paintings and drawings and photographs, evidence of Frank Moore's vision and LaBash's graphic genius.

I don't know to what extent I could have gone with the flow at a Frank Moore performance. I suspect not very long. Not wired that way. But I do know that sitting and talking with Mac and LaBash was enchanting—Moore through a filter. Their world is one that could not survive or even exist in many places on the planet. We are in Berkeley though— and they exist and survive and carry on.

In the copy of *Frankly Speaking* that Mac and LaBash gave me, they wrote "Glad you knocked on our door." I am glad that my *flaneur* ways took me to their door and that they opened it.

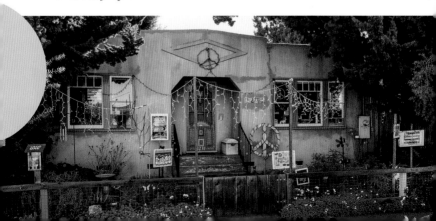

BEAR BASICS
(FORMERLY RASPUTIN MUSIC)

KEN SARACHAN

2350 Telegraph Avenue

Bear Basics on the southwest corner of Telegraph and Durant was the original site for Rasputin Music, now a block south on Telegraph. Rasputin's is owned by Ken Sarachan, a well-known figure of Telegraph Avenue. He is also sometimes a patron of the arts, as seen here.

Sarachan installed a number of Bulwinkle pieces at the original Rasputin's, which are still part of the decor at Bear Basics. They are manic musicians and manic staff notations.

Sarachan also contracted with the artist Martin Metal. After Bauhaus-inspired training in Chicago in the forties, Metal moved to Berkeley and for fifty years made art in virtually every medium. For the Rasputin/ Bear Basics project, Metal designed and fabricated railings made from brass, copper, perforated tin, and compact discs. The skylight on the top floor is also a Martin Metal piece.

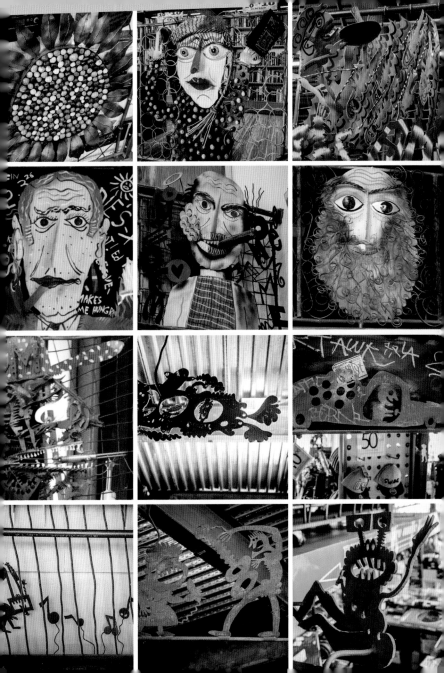

FAIRY MURAL

RILEY AND STEFEN

1110 Chaucer Street

Riley—her standalone name—lives on Chaucer, just above San Pablo Avenue. Her life's work is returning urban creeks to the natural state and functioning of the creek in support of biodiversity, recreation, flood management, and landscape development.

Stefen—his standalone name—lived in the house, which was then a duplex, in the early 2000s. Stefen has been making murals in Berkeley and the Bay Area for more than forty years. His iconic Dutch Boy mural at Milvia and University was the first street mural in Berkeley.

Together, Stefen and Riley researched, designed, and

painted the mural that wraps around Riley's house from east to west facing Chaucer and then around the western side of the house, climbing up a chimney in the process. The mural is built around California native plants and little people, the fairy realm—elves, leprechauns, gnomes, and trolls.

On the northeast corner of the house, a British fairy has attached itself to a blooming foxglove. A brownie from Scotland strolls toward a bowl of milk just around the corner. Brownies are real Goody Two-shoes and help with housework. A goblin has snuck out from under the house to steal the milk. Poor brownie.

A redwood stump suggests the unfortunate state of California's redwood forests. At the base of the redwood tree is a fairy-elf painted next to a door that lets into the house, where the fairies make strange noises, misplace things, lose socks, and hide important papers. A troll waits under a bridge. To his left, you can see a troll who somehow got turned into stone. Stone happens! Fairies climb up a honeysuckle vine to the fairy house on the roof. A flying fairy watches from the east.

There is another opening to the house. This one is guarded by a deer mouse with a red hat. That means that the mouse has unusual powers and abilities. In the final corner of the mural there is an Irish little person next to a pot of gold. Normally a little person does not allow themselves to be viewed or painted.

The research and attention to detail is amazing. It is a primer on little people and on California natives that is a great child destination—find the fairies! Stefen is committed to his art. Riley is committed to creek restoration. The mural rings with their passions.

UPDATE: In the fall of 2017, I learned that Riley had painted over the lovely mural on her house. It had degraded significantly, and rather than repaint the mural she painted over it. This is the fate that befalls much quirk—art is not eternal. For me, it just means to get out and see and enjoy what is there today. It might not be tomorrow.

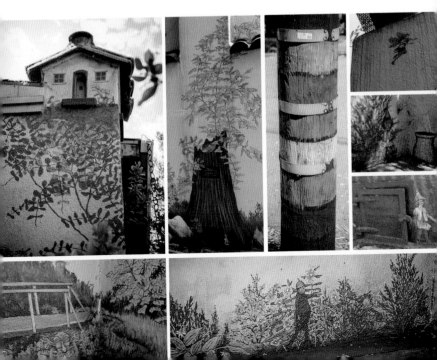

DRY GARDEN NURSERY
RICHARD WARD AND JINPA NYIMA
6556 Shattuck Avenue

Richard Ward and Jinpa Nyima run Dry Garden, which has cactus, succulents, California natives, drought-tolerant bamboos, low-water perennials, grasses, and trees. The nursery began in 1987 as Bay Area Succulents. It was a decade-long dream of Ward and a Nashville friend, Keith Calhoun. Nyima is a former Tibetan monk, now married with children. The Buddhist imagery and iconography in the nursery are his influence.

Dry Garden also has a good deal of Mark Bulwinkle art—cut steel, carved stone, cut metal panels lacing the windows of the shop, postcards, and tiles. Everywhere.

Ward has known Bulwinkle, who is a skilled and creative gardener on the side, for many years; and the migration of Bulwinkle art into Dry Garden makes sense. Of Ward Bulwinkle says: "He is a fine person. He has been most kind and non-judgmental toward me, which can be difficult for many."

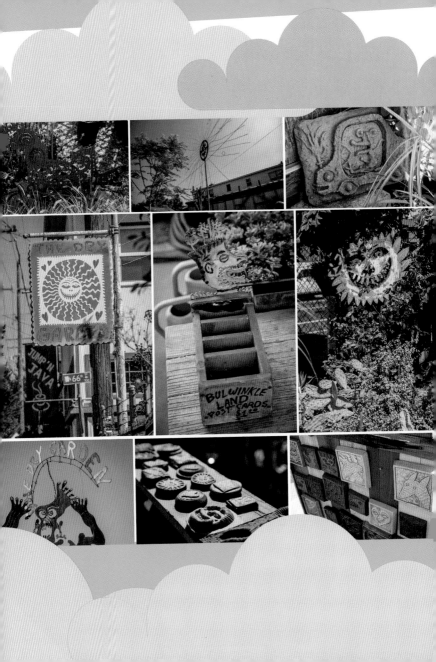

NICARAGUAN ARMS AND LITERACY MURAL

JANE NORLING

2742 Martin Luther King Jr. Way

In late 2013, John Storey and I went to Jane Norling's home to photograph a mural in her yard that I had glimpsed during my Tom-the-*flaneur* walk of MLK. Jane happened to be looking out the front window at the very moment John held his camera up over the fence to shoot the mural. She was curious and came out.

A lesser *flaneur* would have cut and run, but I explained the Quirky Berkeley mission and I soon had a new best friend. She introduced me to her husband, Bob Lawson. I had last seen him in Calexico in late 1976,

where we both were working on a United Farm Workers organizing drive. Small world!

In the sixties, Norling was a member of the Peoples Press collective in San Francisco. They designed, printed, and published movement literature, community flyers, posters, and small books. She designed and printed. For several months she worked for an international solidarity organization in Havana.

The Norling mural that can be seen over the fence was originally painted in 1984 as part of the Balmy Alley mural project in San Francisco. Artists painted murals along the alley, celebrating indigenous Central American cultures and protesting U.S. intervention in Central America. In the eighties, President Reagan was supporting corrupt and brutal counter-revolutionaries in Nicaragua, the ruthless Duarte junta in El Salvador, and had supported the scorched-earth military dictatorship of José Efraín Rios Montt in Guatemala.

Among the murals on Balmy Alley was Norling's *Darles Armas y Tambien Ensenarles a Leer* ("Give them arms, but also teach them to read"), a celebration of the literacy campaign that had been undertaken by the Sandinista government in Nicaragua.

When the Balmy Alley landlord eventually took down the fence, Norling was able to rescue her mural, plank by plank, and bring it to her home in Berkeley. Once the mural was removed from its original context, she saw no

need to maintain it in a pristine state. "I have enjoyed watching it go the way of time. From where I sit at my computer, I see my favorite figure—painted from a photograph by Margaret Randall of a Sandinista *brigadista*. The painting is part of our local environment in Berkeley." She has it loosely installed in her Berkeley yard, leaning against a fence, lightly secured by horizontal wires.

I have blogged extensively about murals, but not chosen any for print until the two I have selected for this volume. Norling's is a beautiful example of political art; its disintegration over time only adds to its appeal. It is a reminder of a different time when we, well, *cared* about what our government was doing abroad in our name. It is a mural with a story, a story of a second life after sure demolition in San Francisco. And it is a mural painted by a kind and compassionate and tough-as-nails Daughter of Berkeley.

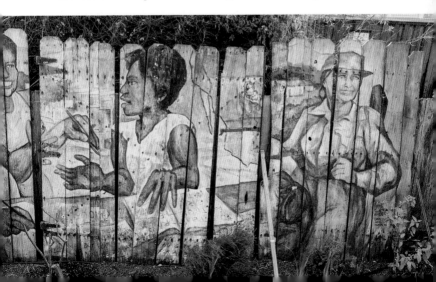

JUMP'N JAVA
MIKE DAWOUD
6606 Shattuck Avenue

The brightly painted cut metal sign outside the store and the west-facing windows, door, and clerestory windows at Jump'n Java present a stunning collection of Mark Bulwinkle's cut metal art. Bulwinkle's journey: M.F.A. in fine arts (printmaking) from the San Francisco Art Institute, industrial welder for Bethlehem Shipyards, then artist with a welding torch. Mexican *papel picado* inspired Bulwinkle, and the cut metal in the Jump'n Java windows is evocative of intricate Mexican cut paper.

Mike Dawoud owns Jump'n Java and is behind the counter 364 days a year. A Jordanian Christian, Dawoud closes shop on Christmas day. He has been in the Bay Area for years, first managing coffee shops for others and then, for the last ten-plus years, running Jump'n Java. He and Bulwinkle are friends—simple enough. Bulwinkle has filled Jump'n Java with his art: the window pieces and cut steel and cut metal pieces inside. Dawoud sells a small assortment of Bulwinkle work—tiles and postcards.

There is Bulwinkle art to be seen all around Berkeley, but Jump'n Java's west-facing windows present as stunning a view of his cut metal work as is to be found in one place.

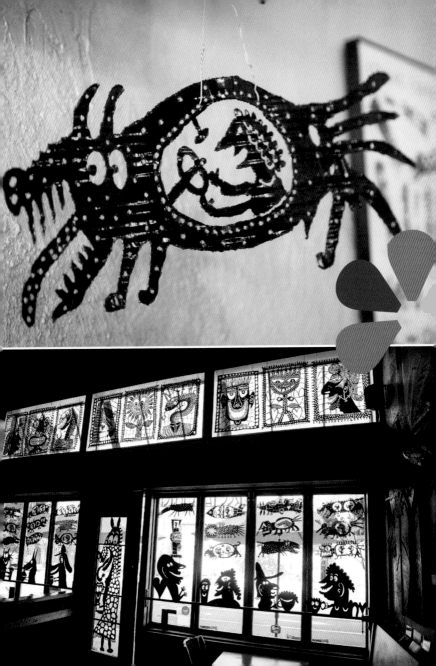

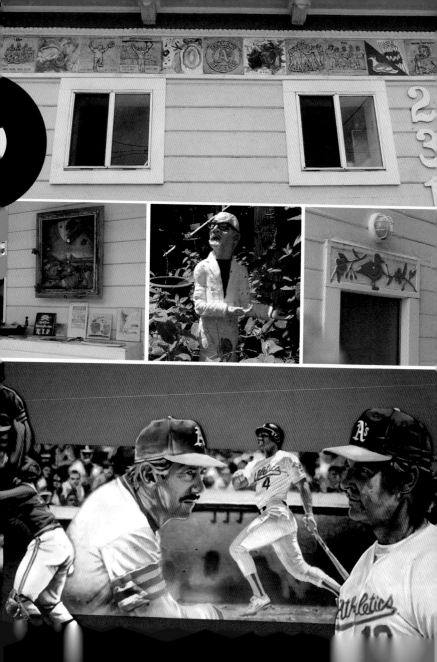

BASEBALL BAS-RELIEF
JOS SANCES AND
ROBBIN LÉGÈRE HENDERSON
2310 Ninth Street

I am fond of the Greil Marcus term "old, weird America." Baseball is the epitome of old, weird America. It once was the national pastime, a graceful sport with no clock and long stretches of exquisite boredom, of eternal hope and eternal summer and eternal youth, green grass and white lines and 3 strikes and 3 outs and 3 bases and 9 players and 9 innings.

The house in question is just south of Bancroft, on a modest block where men work on cars with Mexican pop music blasting. The block is home to the landmark R.R.B. Apartments. The house looks like a converted garage maybe, or just a house built right up to the sidewalk line.

The architecture screams late nineteenth century. Just below the roof are a series of home-crafted bas-relief.

The *bas-relief* (or for those who prefer the Italian to the French, the *bassorilievo*) is vernacular art at its finest. The panels honor the players, managers, and announcers of the A's, especially those of the seventies and eighties. Since they moved from Kansas City in 1968, the A's have been the Bay Area's grittier, bluer-collar baseball team, the team of the old, weird East Bay.

The panels on the left celebrate early minor league California League baseball in Oakland in the nineteenth century; professional cheerleader Krazy George Henderson, who claims to have invented the "wave" crowd cheer on October 15, 1981, in an ALCS game between the Oakland A's and the New York Yankees; and Rickey Henderson's 1991 stolen base #939 that broke Lou Brock's record. The panels on the right celebrate the 1989 world champion Bash Brothers, who defeated the Giants in a World Series interrupted by the Loma Prieta earthquake; the 1972 world champion A's who, behind the heroics of Gene Tenace, won the World Series for the first time since 1930; and the late Bill King with his "Holy Toledo" home run calls. Bill King was also famous for "Not in your wildest alcoholic nightmare would you ever imagine such events unfolding!" but apparently it did not fit.

The boys of summer live on. They are pretty amazing. From the heart.

Two artists live here, Robbin Légère Henderson and Jos Sances. Henderson is a plein air painter and a wood-block printmaker. Stunning work. Sances is a printmaker, ceramicist, wood-carver, political activist, and operator of Alliance Graphics. His work is apt to include popular cultural references. He is a member of the Great Tortilla Conspiracy, a collective dedicated to making tortilla art.

The baseball tiles were made by Robbin, Jos, their son Dar, their daughter-in-law Anissa, and grandchildren Max and Amira. All are A's fans. The tiles are unabashed in their love of the A's, of baseball, of the old, weird East Bay.

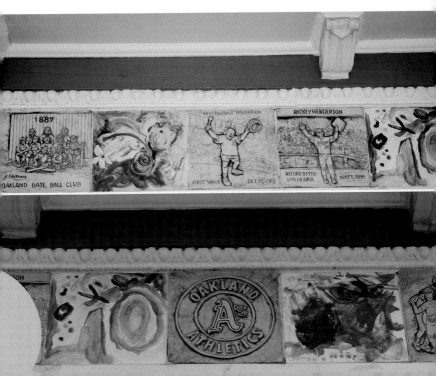

MAD MONK CENTER FOR ANACHRONISTIC MEDIA

KEN SARACHAN

2454 Telegraph Avenue

Ken Sarachan has been a friend to and patron of Mark Bulwinkle. When Sarachan bought the old Cody's Books on Telegraph, he turned to Bulwinkle for art.

Over the summer of 2015, the outdoor work slowly appeared on the second-floor balcony facing Telegraph—brightly painted and powder-coated panels depicting the flora of Telegraph Avenue, fantastical flowers and bloom spikes and foliage. Cut heavy steel creatures followed on the balcony railing, and cut metal sconces lined the wall.

Inside Mad Monk, there are nine painted-metal portrait sculptures by Mark Bulwinkle, depicting iconic Berkeley figures, both late and living—Mario Savio, Julia Vinograd, Robert Oppenheimer, Grigori Yefimovich Rasputin, Malcolm Margolin, Moe Moskowitz, Bulwinkle himself, and Ken Sarachan and Laurie Brown Sarachan. Yes, I know, Rasputin never hung out in Berkeley, but he was very important to Sarachan, whose flagship music store is named after the monk.

Last—the restrooms feature Bulwinkle tiles as accents.

I consider Bulwinkle the true north of Quirky Berkeley. If you spend a few minutes at Mad Monk checking out his art it is hard to believe that you won't agree.

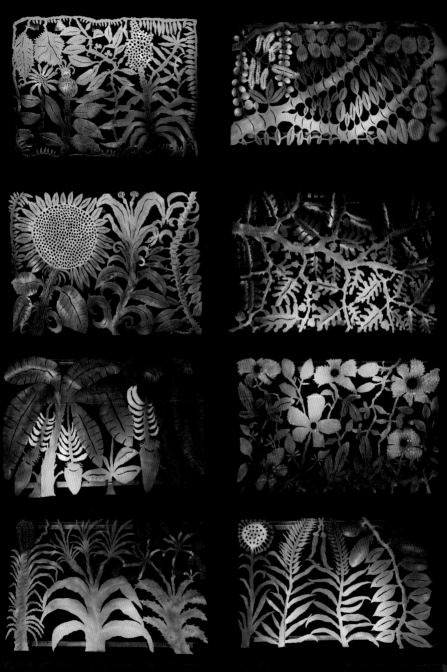

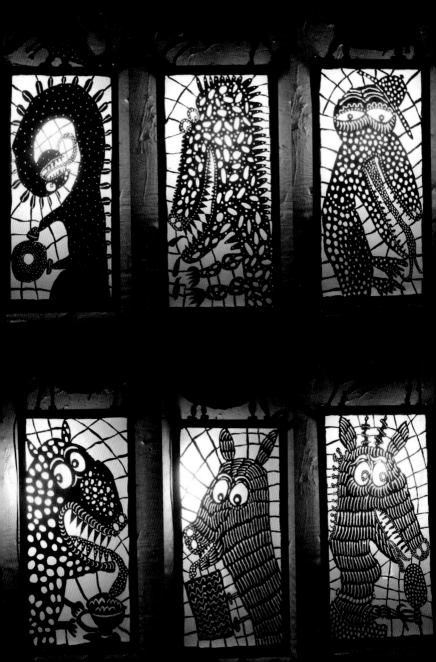

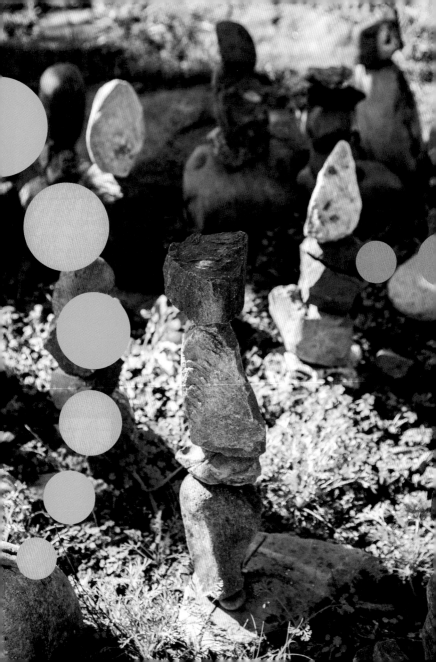

SMALL WORLD AND AXIAL ROCKS

MAC MCILROY

1422 *Fifth Street*

What first caught my eye in front of 1422 Fifth Street were the balanced stones. I'm not sure, but they may be called cairns. A cairn is a human-made pile or stack of stones. There are lots of them here. Somebody has got the balance thing down.

The balanced rocks are the work of Mac McIlroy. He has lived here since about 2000 and has been working on a drought-tolerant front yard since then.

McIlroy explains that he grokked rock balancing by studying history. He particularly studied the Pythagoreans and Pythagoreanism. He figures that they got it all wrong—things don't fall down, they fall up. "The rocks want to fall up. You just find the center and let them fall up." I was

reminded when he said this of *The Hitchhiker's Guide to the Galaxy* and the flying instructions there—"There is an art to flying, or rather a knack. The knack lies in learning how to throw yourself at the ground and miss. Clearly, it is this second part, the missing, that presents the difficulties."

The published authority on rock balancing is George Quasha. He explains that he discovers an unknown axis that brings the rocks into radical alignment. The stones "learn" this state of levity in contrast to their ordinary state of gravity. That doesn't sound any more far out than rocks falling up. McIlroy clearly has a knack for rock stacking. Based on his success I have to say that the idea of letting the rocks fall *up* cannot be discounted.

Behind the balanced rocks is a trapezoid-ish raised bed with gravel, rocks, and dozens of small figures. I like to think of it as a kind of small world. It is about five years old. McIlroy estimates that he has spent no more than fifty dollars on it. Most of the animals are sidewalk finds; some are left by neighbor kids. I asked McIlroy if the small world tells a story. "Yeah. The story is—it's very funny."

Then I asked if he had ever done anything artistic before or whether this was his first endeavor. He has. He was a guitar player with punk bands, the Noise Boyz and Leroy's Pleasure Missile. I asked how many chords a guitar player in a punk band has to know. "It's not the chords. It's the amp. The chords don't matter, just the amp. The Marshall 100 watt was the answer. In certain

ranges I'm deaf thanks to the Marshall." He sports a fading old-school tattoo that reads "Wise Up or Shut Up"—great advice now as always.

So there it is. A quirky aging punk rocker who has created an enchanting small world with balanced rocks based on the premise that the rocks want to fall up—a perfect destination visit for Quirky Berkeleyites with kids. A few houses to the north, at 1406 Fifth Street, is the home of Rob Garross with a caboose in the driveway. Just south of the small world, half a block up Page Street, is Doug Heine's sculpture studio and the airplane crashing into his roof. A destination for kids for sure—three major manifestations within about a block.

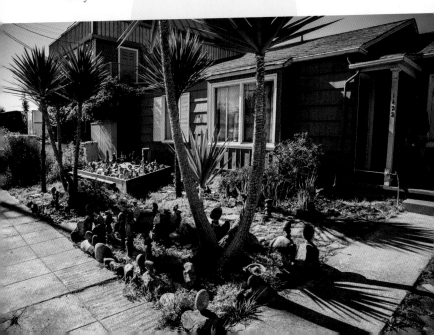

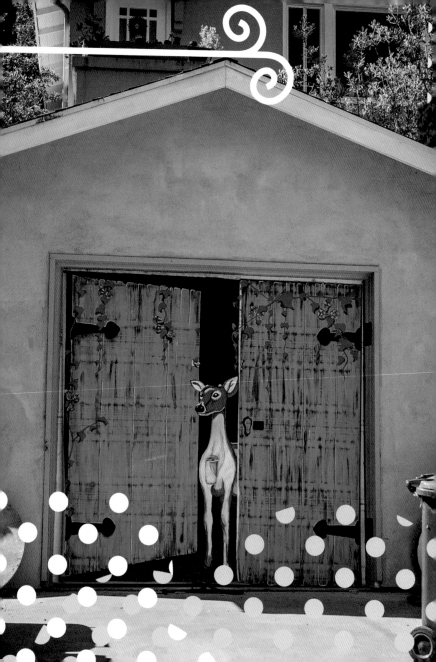

ACKNOWLEDGMENTS

I acknowledge Steve Wasserman, who embraced Quirky Berkeley with the same passion with which Malcolm Margolin had. I am proud to be in the Heyday of Wasserman.

Briony Everroad for her careful editing and Diane Lee for her art direction;

John Storey's eye and genius photography;

Traci Hui, who sketches like nobody's business.

Colleen Neff and the Berkeley Path Wanderers, who have embraced Quirky Berkeley and given me the chance to lead walks;

Anthony Bruce and Daniella Thompson of BAHA;

Steve Finacom of the Berkeley Historical Society, and the Berkeley Breakfast Club, great supporters;

Frances Dinkelspiel and Tracey Taylor of *Berkeleyside*, whose generous support brings *Quirky Berkeley* to a larger audience;

Jay Firestone and Bernie Samson for their help with the website;

Lastly, John English and the Chilton Street neighbors of The Village. Your fight to keep Berkeley the beautiful Berkeley that we love inspires me.

ABOUT THE AUTHOR

Tom Dalzell has lived in Berkeley since 1984. He has worked as a lawyer for the labor movement for his entire adult life. He has written extensively about slang. He has been methodically walking the streets of Berkeley since late 2012 in search of quirky stuff, blogging about it since 2013. *The New York Times* described him as looking "too strait-laced to be the arbiter of the eccentric." He accepts this verdict.

ABOUT THE PHOTOGRAPHER

From the ripe old age of sixteen, John Ross Storey always knew his career path would involve photography. Embarking on that trajectory at eighteen, he began his photojournalism career at *The San Francisco Examiner*, followed by stints working with the Associated Press, *People Magazine,* and the *San Francisco Chronicle*.

ABOUT THE ILLUSTRATOR

Traci Hui was raised by wolves and books, in a house made mostly of pink carpet. She now lives in Oakland with her cat, Crow, in their own private junglet. When she's not designing things for money, she likes making comics, traveling, and eating cheeseburgers.